in the
# stilllife

in the
# stilllife

PHOTOGRAPHS BY CHARLES H. TRAUB

INTRODUCTION BY LUIGI BALLERINI

# And Then Again BY LUIGI BALLERINI

The spherical does not repose on the spherical, because they touch each other at a point; but the concave rests on the convex. And morally, the proud man cannot get together with the proud man, the poor man with the poor man, the greedy man with the greedy man; but the one is pleased with the humble man, the other with the rich man, the latter with the munificent man. However, if the matter is considered physically, mathematically, and morally one sees that the philosopher who has conceived of the theory of the "coincidence of contraries" has not discovered little, and that the magician who knows how to look for it where it does exist, is not an imbecile practitioner.

— GIORDANO BRUNO

Private faces in public places are wiser and nicer than public faces in private places.

—W. H. AUDEN

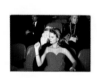

Whether or not God plays dice with the universe, or whether He does so squarely, we may never find out. Driven by the desire to hang on to some form of determinism, albeit a much watered down version of it than that circulated by nineteenth-century scientific enthusiasts, Albert Einstein was fond of repeating that God did not.

The first instance of this assertion may have come as early as December 4, 1926, when Einstein wrote to Max Born, a noted colleague, "I am convinced that He does not play dice." It is, of course, one of the most often repeated phrases of the twentieth century, and it bears witness to at least one fact: the uneasiness with which the proponent of relativity reacted to the notion, introduced by quantum mechanics, and made even more cogent by the uncertainty principle, that the universe is governed by probabilities, since, as it were, in the subatomic world nobody has yet been able to measure simultaneously the speed and the position of a given particle.

To see where a particle is located, Werner Heisenberg pointed out, light must be shone on it; however, this seemingly innocent action affects the behavior of the particle itself and changes its speed in unpredictable ways. The conclusion reads as follows: the keener you are in ascertaining the position of a particle, the vaguer you will have to be with regard to its speed. You know the particle is present; you simply don't know where it is.

Accepting the noncoincidence of true logic and verifiable fact[i] may enable us to reelect the imagination to a meaningful post in the game and gamble, not merely of science but of all cognitive activity, including the mindlessness of the snapshot. It may open quasi-magical doors beyond which thinking is immune from profit, and humans can protest their ignorance of original sins, as well as of any other diabolical tricks deployed by the wizards of Oz of all times to persuade them that their purpose in life is to achieve purification.

To acknowledge, then, as Wallace Stevens does in his poem "The Creations of Sound," that "speech is not dirty silence / Clarified. It is silence made still dirtier," may grant psychological plausibility to merely logical possibilities and indeed reestablish the paratactical mode as the natural grammar of both poetry and science—and the mix thereof that constitutes, today, the essence of Charles Traub's photography. Are chaos theorists not speculating that, in the subatomic world, the smallest occurrence can set off chains of events rife with all kinds of unpredictable consequences? If the perception of the color red can be the underlying sensorial connection between analogically related portions of a poetic texts featuring, let us say, the distant realities of "sunset," "blood," and "cherry," is this not like saying that the flapping of a butterfly's wing can ultimately be listed as the remote cause of a tornado? And doesn't the same apply when, as it happens in this book, those realities are replaced by two red blankets (p. 26), two red sweaters (p. 34), and the red backdrop of a shop window (p. 67)?

When confronted with events that seemed to have been brought about by chance, or the indefinition of which would not automatically rule out the reality of their existence (a logically unavoidable and yet ultimately unmeasurable existence, an existence without a pudding to prove it), Einstein would painstakingly overcome the difficulty by assuming that they were random events in appearance only, and that there was what we, nowadays, would call a hidden variable at work in an otherwise perfectly rational universe.

In "Einstein's Dream," a lecture given in Tokyo in 1991, and subsequently published in his *Black Holes and Baby Universes*[ii], renowned British physicist Stephen Hawking reminds us that, despite Einstein's reluctance to embrace the full implications of quantum mechanics, introduced a few years earlier by Max Planck, it was indeed a paper authored by Einstein in 1905—the same year he wrote his paper on the general theory of relativity—about a phenomenon called photoelectric effect that freed quantum mechanics from the merely theoretical (which is where Planck had left it) and vested it with an unsuspected correspondence to physical reality. As Hawking explains, "It had been observed that when light fell on certain metals, charged particles were given off. The puzzling thing was that if the intensity of the light was reduced, the number of particles emitted diminished, but the speed with which each particle was emitted remained the same. Einstein showed this could be explained if light came not in continuously variable amounts, as everyone had assumed, but rather in packets of a certain size," which were indeed no other than Planck's quanta[iii].

What's uncanny about all this is that Einstein's observation enabled Heisenberg to formulate his "uncertainty principle," in 1925, which, in turn, caused Einstein such anxiety and discomfort and prompted him to utter the words that have occupied us so far. Despite the fact that Einstein was "probably" wrong— the hidden variable theory continues to hold sway in the mind of many contemporary scientists and science historians—and that "all evidence," to quote once more from Hawking, "indicates that God is an inveterate gambler and that He throws dice on every possible occasion,"[iv] it may be a bit of a stretch, to number Einstein—great scientist and profoundly spiritual man that he was—among those who have sedulously arrived at the conclusion that, yes, there is a master plan of the universe and that humans, in the words of Andrew Lawrence, can find their "unique, rigthful and rewarding place in it."[v]

Posting himself on the Internet as a disciple of Albert Einstein, Lawrence even claims to have blazed a cybernetic shortcut leading to such a place with his Life Purpose Program, one of the latest plants to sprout from the surreal new age soil of Los Angeles.[vi] As he asserts in his copyrighted Web site: "There is and

always has been, a wonderful plan in the universe for the human race and a wonderful plan for each individual human being. And it's fairly simple and fairly easy and makes perfect sense…once you understand it." But there is no need to be concerned: "With our program you can avoid the frustration and difficulty of trying to find your life purpose yourself. Discovering one's life purpose is no longer an elusive (and often unsuccessful) quest." In fact, "The Life Purpose Program is now available on line and with this revolutionary online program you can uncover your life purpose…in a matter of minutes!"

Preposterous as this claim may be, it too confirms the suspicion that the search for one's spot in the world may be as good a cause as they come, and that the mere fact of pursuing it qualifies the pursuers as human beings worthy of their name, whether they believe in a perfectly mathematical world or not. And the pursuit requires sharp senses, the gift of curiosity, and, above all, a modicum of self-awareness—which, in turn, has nothing to with the equally preposterous idea that a definite knowledge of the motivations stirring in the subject executing acts (practical or linguistic) can be arrived at, through the deployment of one pattern of formal logic or another. The subject too is a particle deeply affected by the light we shine on it: in fact it may not be much more than the relation established by two or more events of light bent on exploring the wherewithals of their connections.

It does not take much to realize that this subject's search for a meaningful spot somewhere in the physical world and, presumably, in that of the mind as well, constitutes the ostensible referent of Charles Traub's *In the Still Life*, a book of photographic images taken between the mid-1980s and the late 1990s, at a time when the documentary practice that had been photography's principal raison d'être for so many years, began to wane from the horizon of both the image maker and that of his critics and collectors.

True it is, however, that a fair number of animals (dead or alive) also inhabit the pages of the book, and that the photographer's eye has quite deliberately emphasized their similarity with humans in their propensity toward regimentation, pecking orders, and the like (see p. 82, and p. 89, for pigeons and soldiers, respectively). Not only does the disturbing analogy blur the line between universal predictability and original expression, making the quest for humanistic values more fleeting and improbable than ever, but it also casts serious doubts on the notion that the "quest for the meaningful spot" might be undertaken by individuals propelled exclusively by sharp senses—which we assume can be assigned to both humans and animals. It would seem fair to assume that a goal of this magnitude and significance could only be pursued by creatures not lacking in curiosity and awareness, two components believed to be essential to the definition only of humanity.

As the book opens, however, with the image of a highly puzzled cow, straddling the dotted line of an otherwise deserted Irish highway—a place where the "do not drink and drive" commandment is, I assume, enforced as rigorously as it is in Nevada—someone might suggest that the opposite of what has been stated in the previous paragraph can be sustained as well. Dead or alive, animals in a man-made environment tend to assume humanistic qualities. But do they? Can it also be argued that some sort of death drive, indisputably active in the human unconscious, is also present in a number of animals we previously thought to be governed only by the instinct of survival?

Whatever quest the discombobulated cows, stuffed bears, grilled fish, slain deer, stray dogs, or ordely pigeons might pursue in these pages, their relevance is vastly diminished by the pervasive presence of the

human protagonists of *In the Still Life*. If not as numerous as the grains of sand on a beach, the latter are in fact numerous and diversified enough, first, to invoke a comparison with the visitors of the Life Purpose Site[vii] and, second, to invite "readers" to find in them their own simulacrum, to play out the drama of "You thought it was them, and it turns out it is you, instead." No stage is needed for this drama. If the simulacrum is found, there is no need to let anyone know about it. Sharp senses, the keenest curiosity, and an unquenchable thirst for awareness may blend so well in some individuals that, in the secret of their hearts, they may begin to feel a little like Oedipus Rex, though, unlike him, they will be allowed to keep their self-styled oracle to themselves. So they will also be able to stay on as kings. The worst that can happen is that they may develop some exquisite form of perversion.

If they do, they will also notice that despite Charles Traub's enlightened and generous tolerance of the liquidity of postmodern thought, his pictures are gathered here in accordance with some fairly strict numeric progressions and spatial principles. This simple fact may not only help willful readers find their spot in a significant, albeit not necessarily programmable, text of their choice, but also reassure them that although God may be playing dice with the universe, He is certainly not doing so with them.

Having been taken "on the fly" and coming from the spoils of exotic travel as well as from the ordinary sights of a crowded life, the snapshots that make up *In the Still Life* were first thrown haphazardly into a plastic box where they remained, dormant as an uninspiring challenge, for many years. "They did not relate to one another, except of course for the fact they slept in the same tomb," Traub explained in a personal communication. His recent interest in still life painting was the unexpected catalyst of their awakening. Traub was quick to realize the compassionate affinity existing between the two genres of representation, despite the radically different media bringing the images forth. "As a photographer," he notes, "I worked in subtraction, using the frame to bar from the image any temptation that might jeopardize the pictorial excitement. My photographs were still lifes made directly from encased observations of the real world." The symbolic passion that galvanizes the inanimate life of carefully displayed objects is channeled toward discreet examples of animated and, at times, agitated everyday life. In such examples Charles Traub's vibrant and ironic signifiers move farther and farther away from the immediacy of their referential function (which they never deny or reject, however) to promote an autonomous contextualization of their significance. This too comes about, not quite as a surprise, but as a necessitated revelation: as the unpredictable burst of an abstract narrative impulse.

The first segment of *In the Still Life* deals with singularities and isolation, with a firmly established concept of unicity. Yet you need not proceed very far to realize that even the most primary of numbers cannot ignore the urge of duplication (see p. 3, where Traub taking a photograph is photographing himself reflected in a mirror). It cannot, in other words, ignore the individual's desire to connect with the Other within, the unfathomable shadow from which its subjectivity emerges as nothing more than the object of a visually (in our case) signifying predication. All ones are equal but some ones are more one than others: a suspicion of two invites discontent and introduces the dream of repetition; it creeps into the ones, baring their desire to break loose from the assumed and insufferable wholeness of their *erlebnis*.

The second segment collects this tension and carries it to its logical and mature consequences. Twos take center stage acknowledging the tremor of probability and uncertainty, and accentuating, at the same

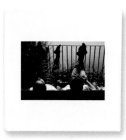

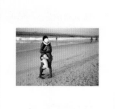

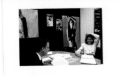

time, the attraction that perennially binds (or separates) their components. The double nature of this attraction is occasionally mitigated by an instance of symmetry (see p. 29) but only to recharge itself in new and humorous precipitations (see the sequence from p. 30 to 32). What ones experienced as constraint, twos experience as nostalgia.

Given that such issues as attraction and separation inevitably imply distance, points of contact, and the quality of both interstice and encounter (real or imaginary), the third segment will have to be called "twos divided." Here we are given an opportunity to gaze meaningfully at the caesura, at the cut between the soundness of the enunciation and the precariousness of that which is enunciated, at the determination of activating their difference as a wobbling pivot. What was implied in the twos is made explicit in the twos divided. Also, that which divides the two may turn out to be an illuminating and effective plan to identify the two ones temporarily juxtaposed in the picture.

The section opens with a quintessential Traub: a picture of a man and a woman kissing on a Brazilian beach and a white poodle jumping up to insinuate itself between them—to pry them open, as it were (see p. 37). But the creation of interstice and the savoring of its quality can also be carried out at a distance. The divider may be a desiring gaze (see p. 42), or the surreptitious presence of an uncommitted referee (see p. 41), the contribution of a dog or of a naked toddler pointing to the mysterious object of his desire in a run-down Jamaican bar (see p. 44 and p. 47).

Inevitably dedicated to threes, the following segment raises the immediate question: What is the difference between a "two divided" and an actual three? Answering it may not be easier than treading on very thin ice, but the thrill of doing so is stronger than any urge to ignore its coaxings. Numerically speaking, this is the most restless and perhaps unnerving section of the entire book. It is here that the definitional aporiae reclaim their logical necessity. As the number to which they page homage, the trinitarian nature of these pictures is ascertained by means of deliberately playful emphases. Compare the "three" engendered (from the left) by a man in a white T-shirt, the drawing of a hatted man on a wall, and the naked arm of a woman combing her hair (p. 55)—or the two checker players turned into a three by the cover of a Frank Sinatra album featuring the singer's face smiling his way between them (see p. 56)—with the three conjured up by the bodily presence of a pregnant woman (a one and a two-soon-to-be) holding between her legs a shopping bag with the effigy of young man bent at the waist and, one might say, ready to repenetrate her body.

This, by the way, is another example of Traub's signature style. Consider the preposterous dwarfing of the man's paper body next to the sculptural mass of the reposing mother: the photograph has occurred first and foremost in the beholding photographer's eye, in his ability to activate a fragment of the social landscape in such a way that a whole scene may acquire the felicitous incisiveness of a close-up. Sharpness and precision of focus introduce a principle of dis-habituation, which surprises the viewer of the photograph no less than the photographer. The real world in Traub's photographs—a world that we all believe to know something about—proves to be real for reasons that we know nothing about, or that we can access only through the saliency of his framing. Here, nothing is arranged to look natural, as, say, in Robert Capa's photograph *Spanish Loyalist* or Ruth Orkin's *Italian Street*. Rather than content ourselves with what we had expected to see all along, in Traub's work we can finally see what is there, no matter how the dice have fallen.

And then again some threes are perfect threes (p. 59 and p. 60) while others are "disturbed," called

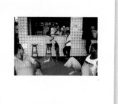

into question, by one (pp. 62 and 69) or by their own background (pp. 63 and 64). Finally there are restless, nervous threes, at times slashed, at times merely frayed by a conflicting (p. 58) or centrifugal gaze (p. 59). It is at this juncture that three releases its grip on measurement and the barbaric hordes of many rush into the city of patterns: its gardenlike promises bend under the unruly performance of human forests.

In Florence (p. 73), as well as in New York (p. 74), and the search for order seems to be either abandoned or artificially satisfied (pp. 77 and 78), and thus not satisfied at all. The segment of *In the Still Life* we have now entered shall be named the land of failed paradigms or, better still, the land where even the most sacred of paradigms parade before our eyes as ephemeral glitters, their provisional necessity clamoring here and there, only to function as remoras; they too will bring to a halt the thousand ships launched by Helen of Sparta against Helen of Troy.

There is only one more step Traub invites us to take after this. Beyond the world of networks and grids and progressions, which are simultaneously man's greatest humanistic achievement and the keenest expression of his death drive, behind the loss of regularity, correspondence, and reliable orientation, behind the loss, that is, of their desirability, lies the world of the desert. In some of its folds, humanity is present in appearance only (see the sequence from pp. 87 to 92); in others it has vanished completely, leaving behind traces of its wit (see, for instance, p. 96) as well as of its ability to recognize beauty, and fear it as the manifestation of an ever resurfacing idolatrous impulse. The photograph of a monument to a picture-taking device, planted in some godforsaken Italian park, concludes the disquieting documentation of our journey from a world of still lifes to the world of a still object, one that will be undoubtedly contemplated and deciphered by visitors from outer space. They might even know if God does or does not play dice with the universe, but who will they tell?

*Los Angeles, February 2004*

---

i   Parmenides maintained that, given the logical possibility of dividing space ad infinitum, fleet-footed
    Achilles would never succeed in catching up with a real turtle "running" ahead of him.

ii  Stephen Hawking, *Black Holes and Baby Universes* (New York: Bantam Books, 1993).

iii Hawking, *Black Holes*, p. 76. It was in fact for this contribution to quantum theory and not, as it is universally
    assumed, for his general theory of relativity that Einstein was awarded the Nobel Prize in 1922. "The idea that
    space and time were curved," Hawking drily comments, "was still regarded as too speculative and controversial,
    so they gave him a prize for the photoelectric effect—not that it was not worth the prize on its own account" (p. 77).

iv  Hawking, *Black Holes*, p. 70.

v   http://www.spiritualminds.com/articles,asp?articleid=126

vi  http://lifepurpose.0catch.com/home.html

vii It boasts visitors and clients from more than 45 countries.

# in the stilllife

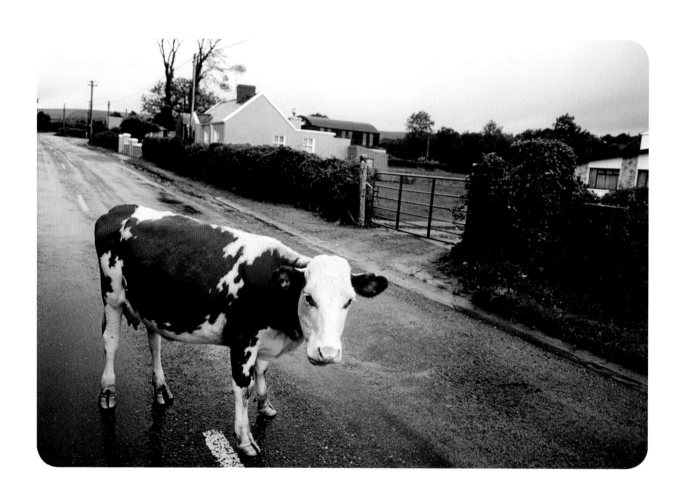

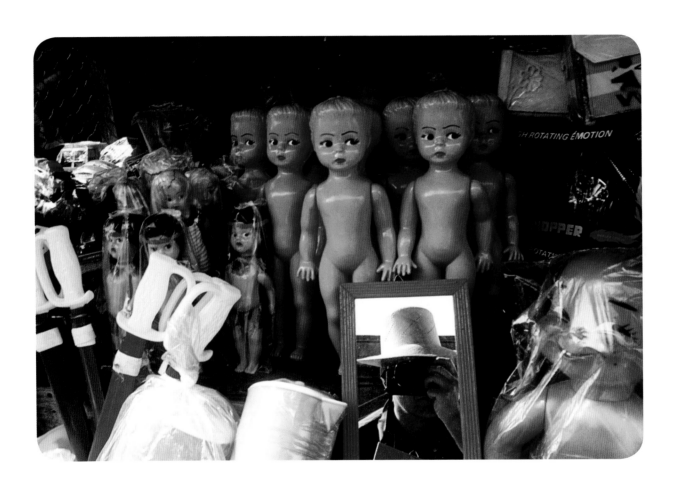

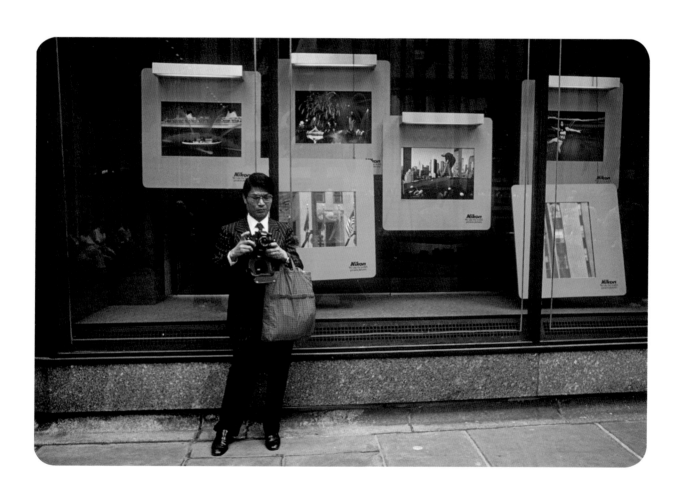

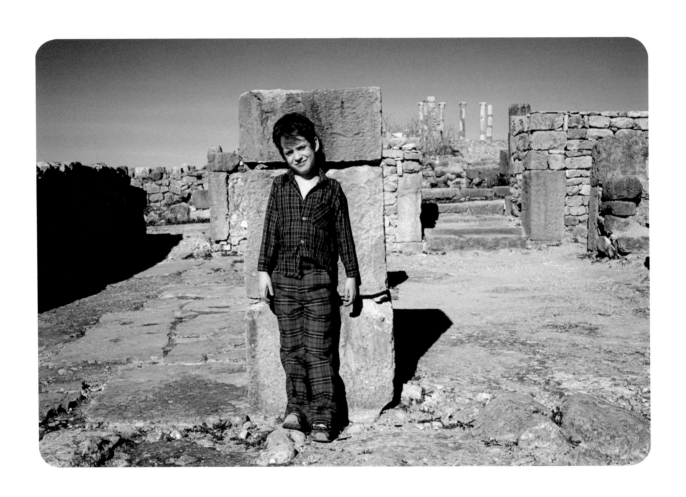

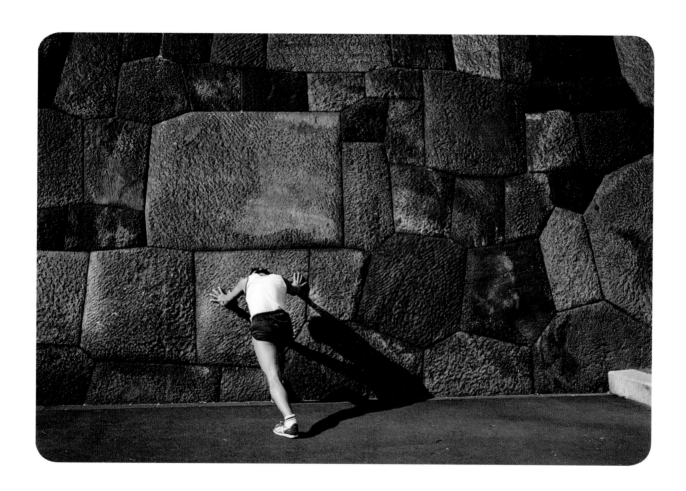

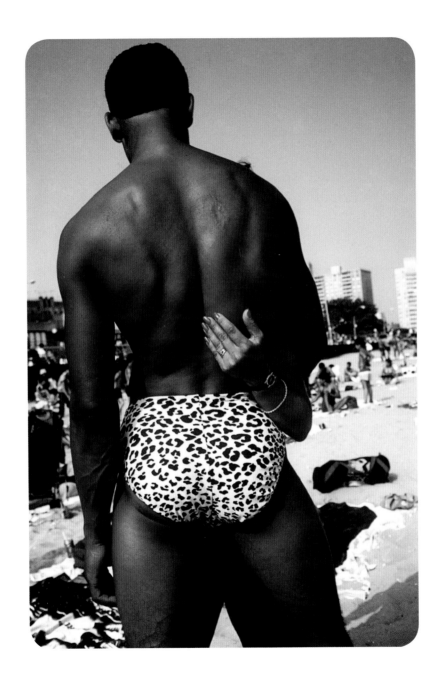

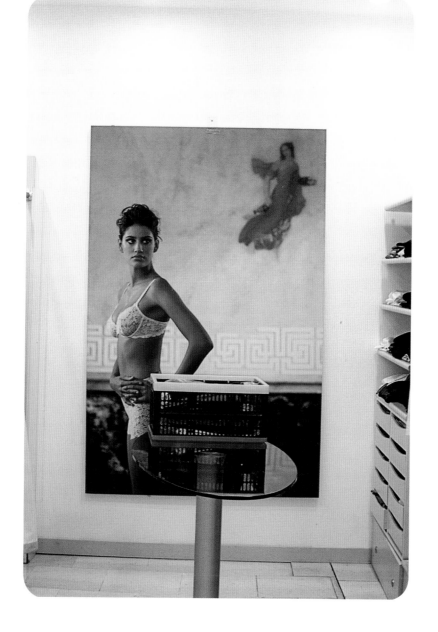

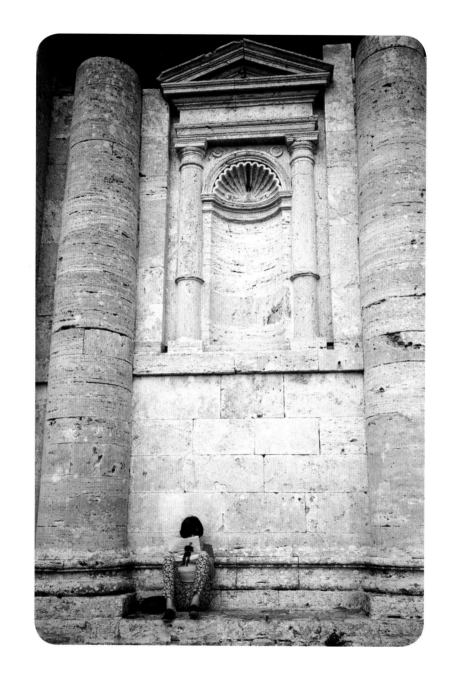

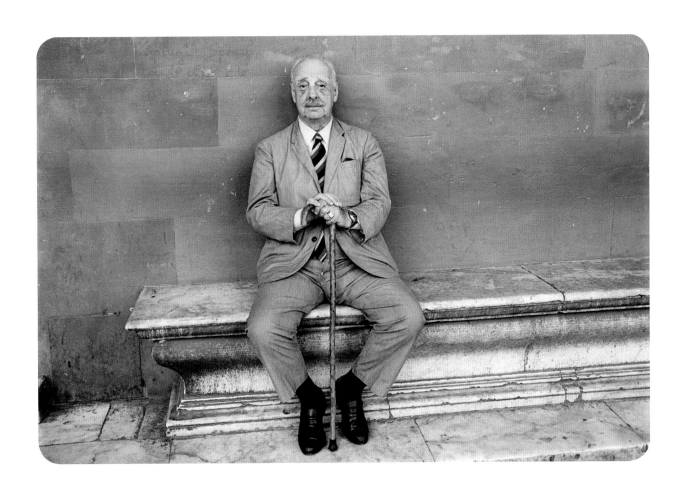

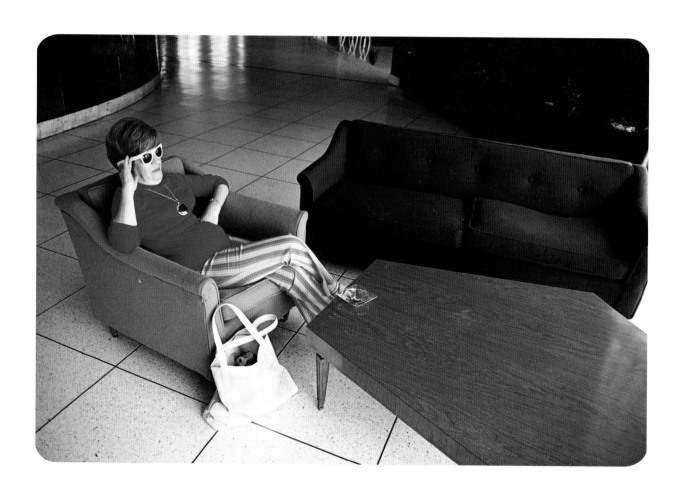

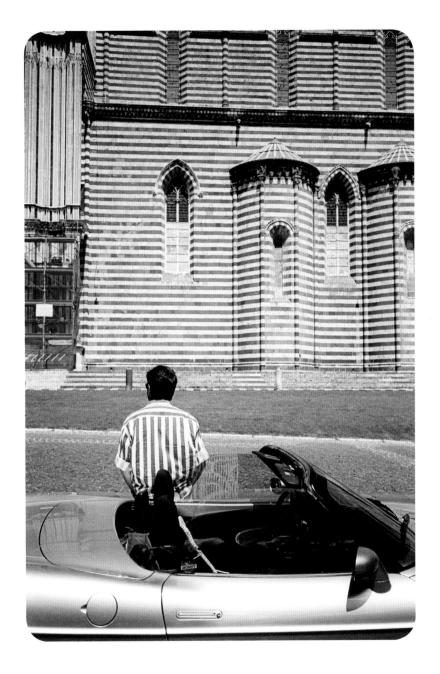

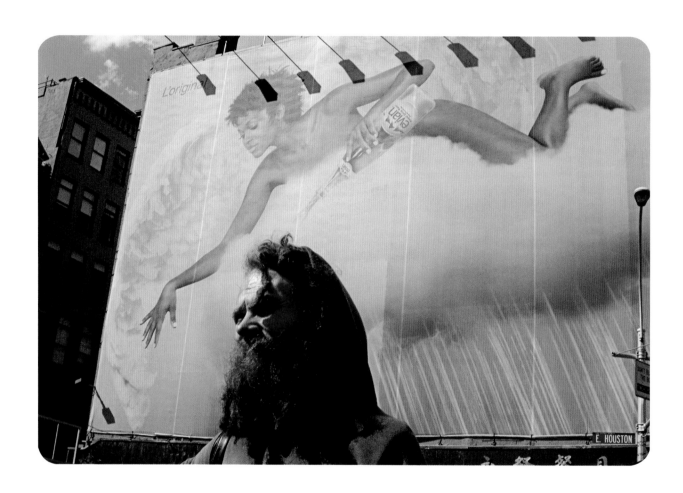

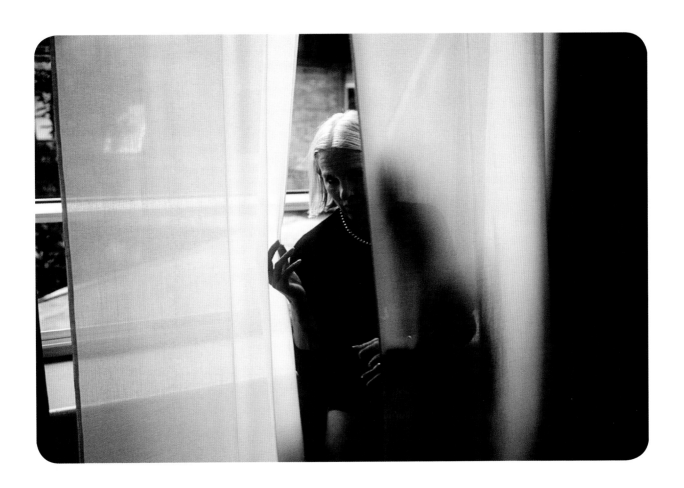

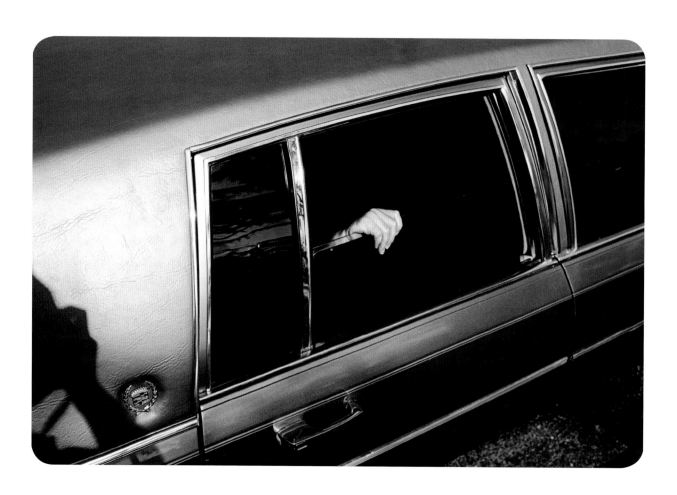

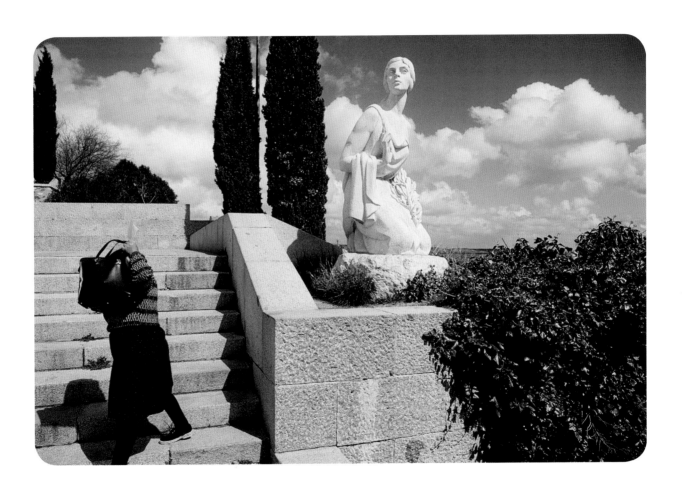

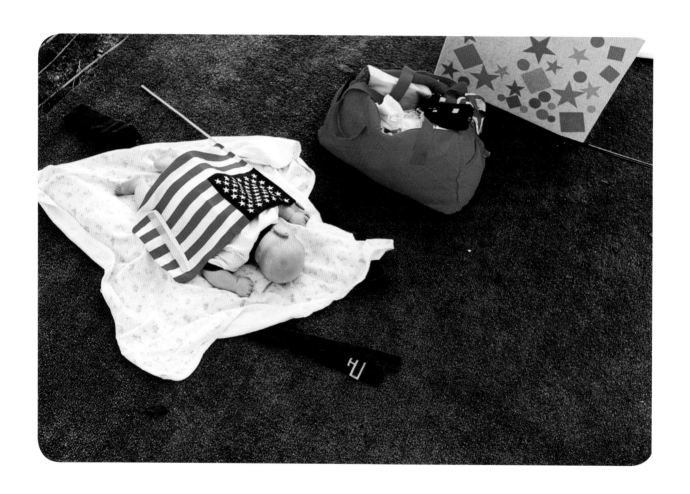

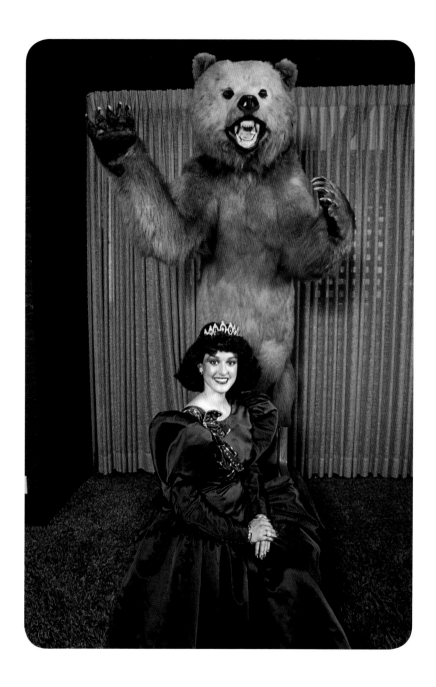

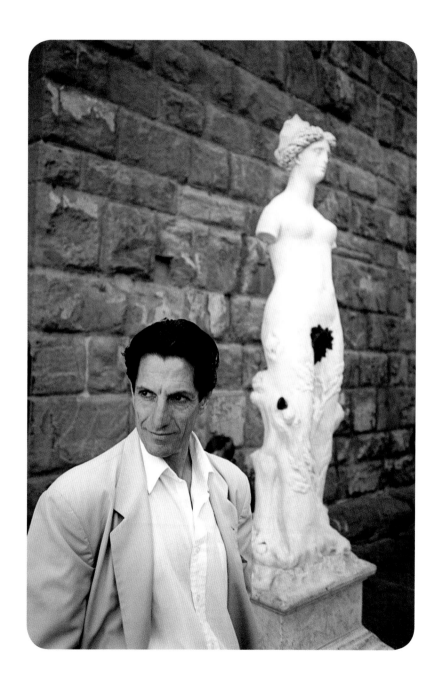

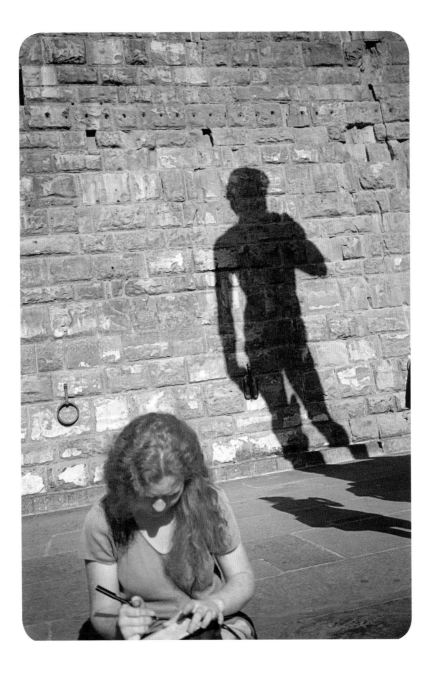

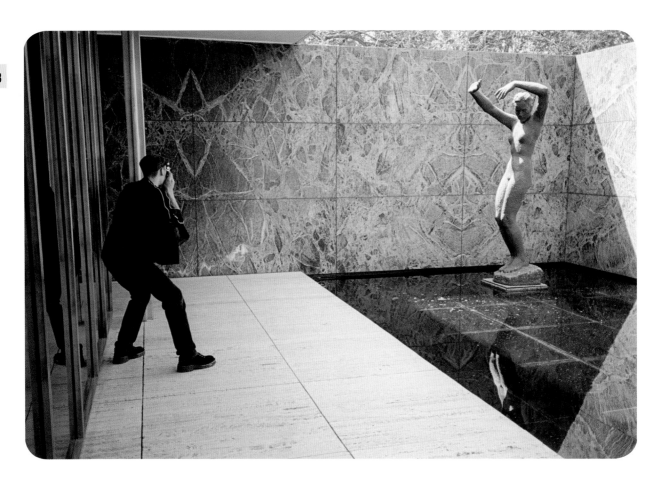

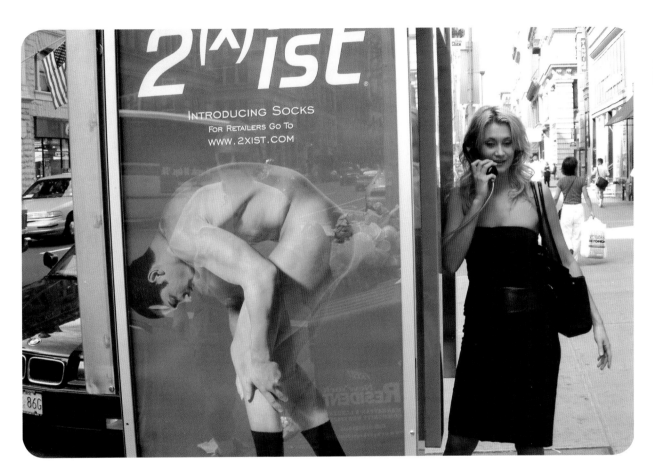

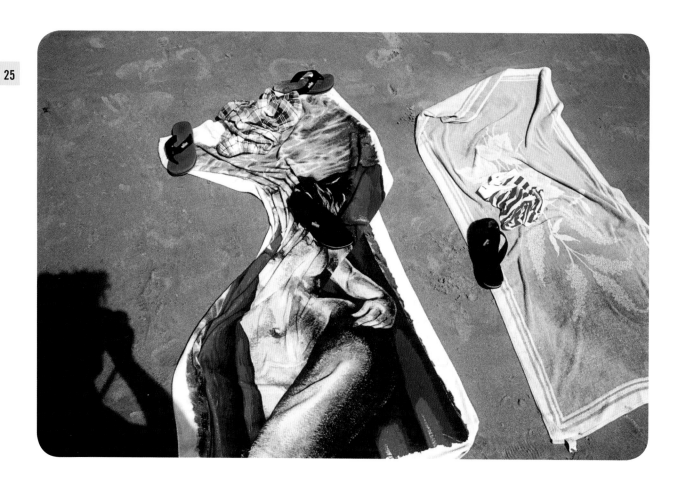

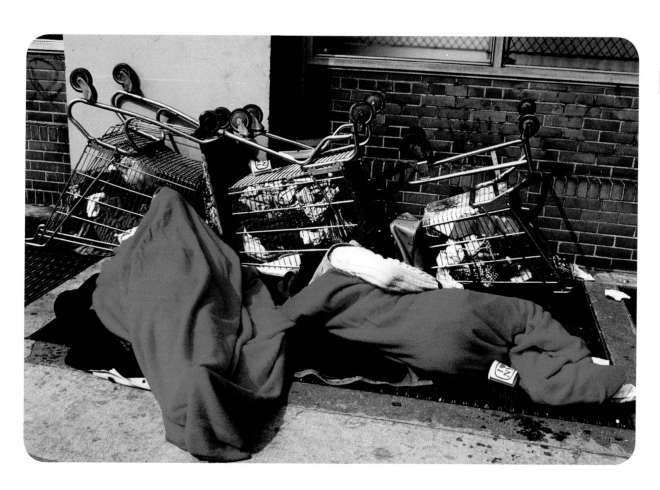

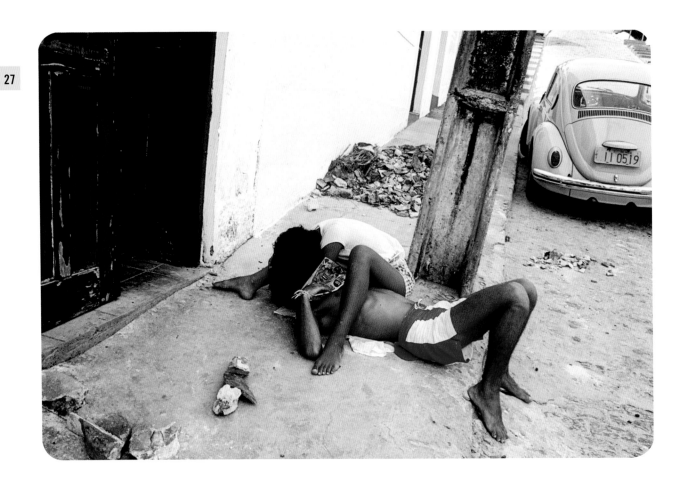

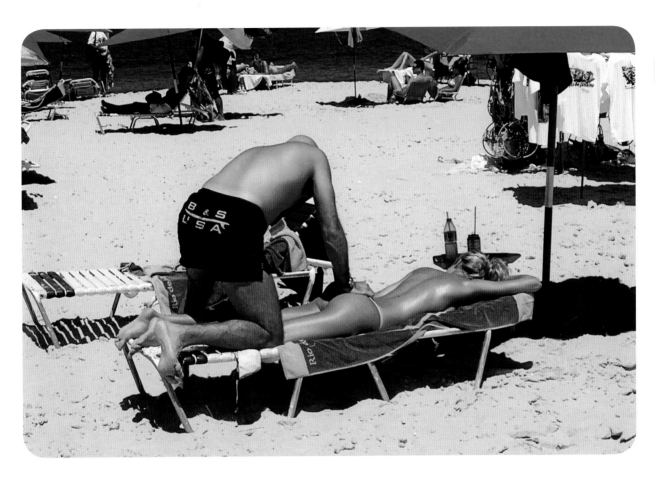

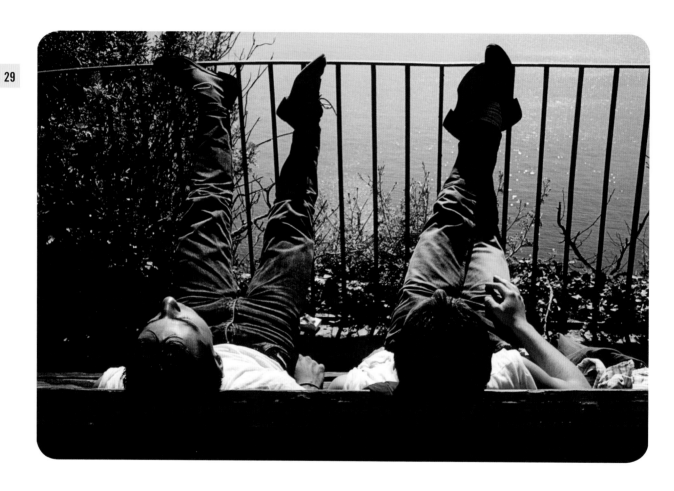

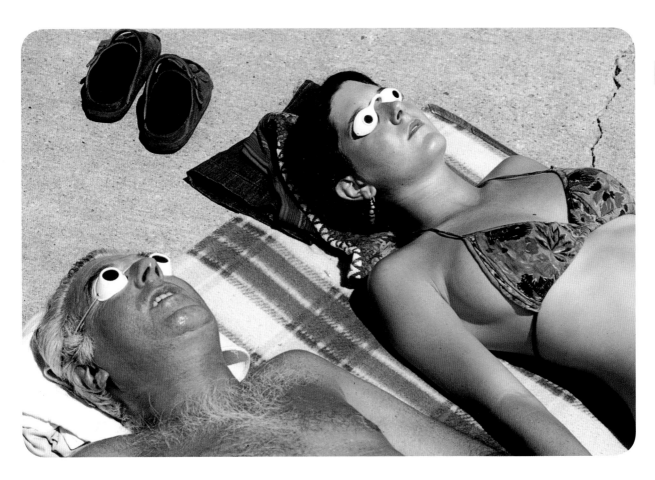

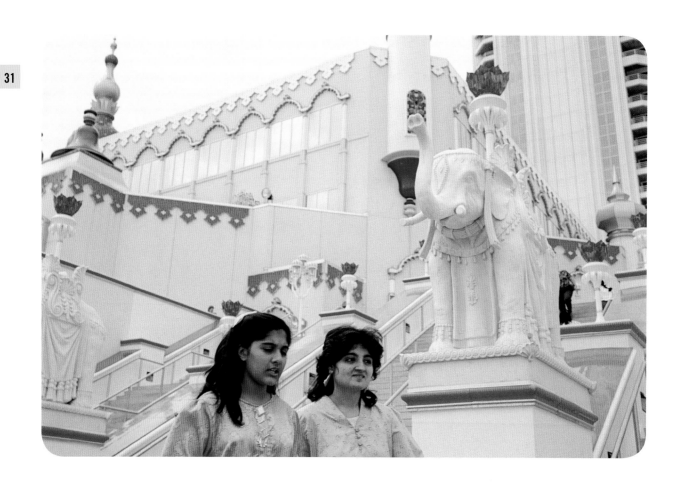

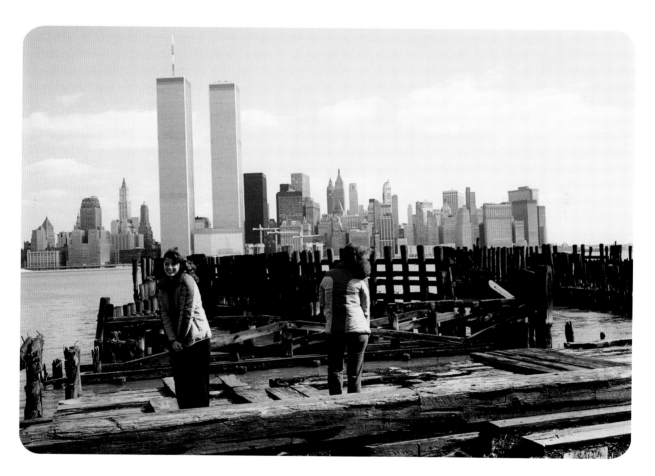

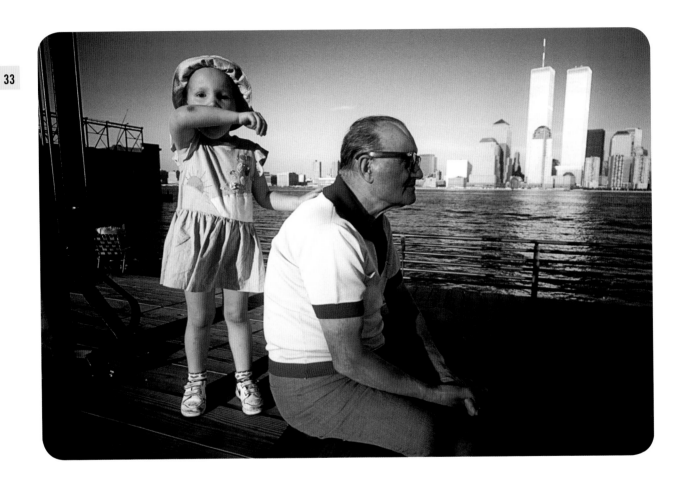

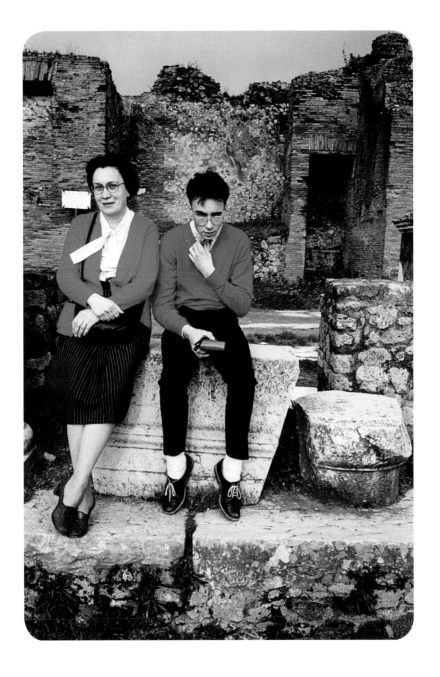

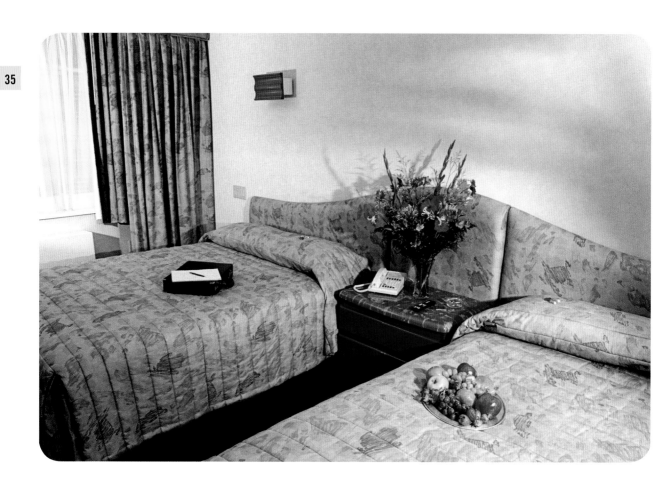

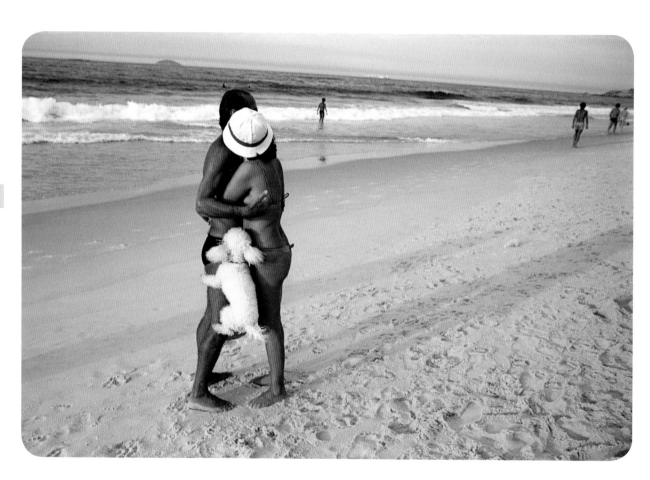

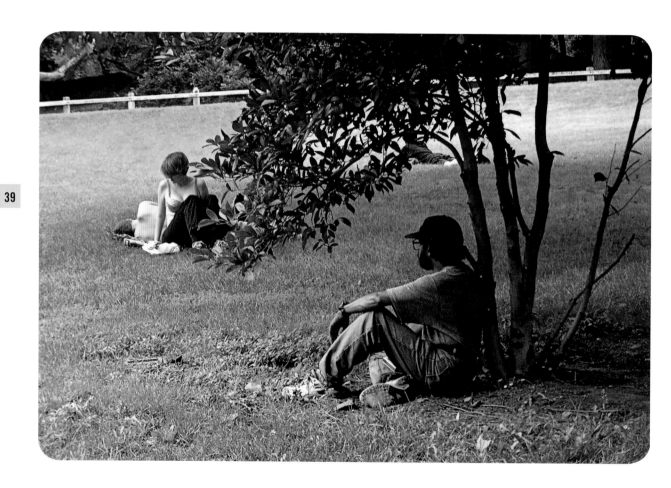

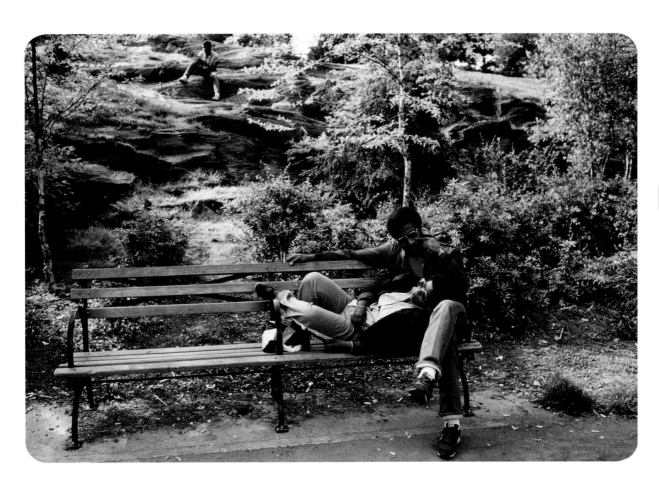

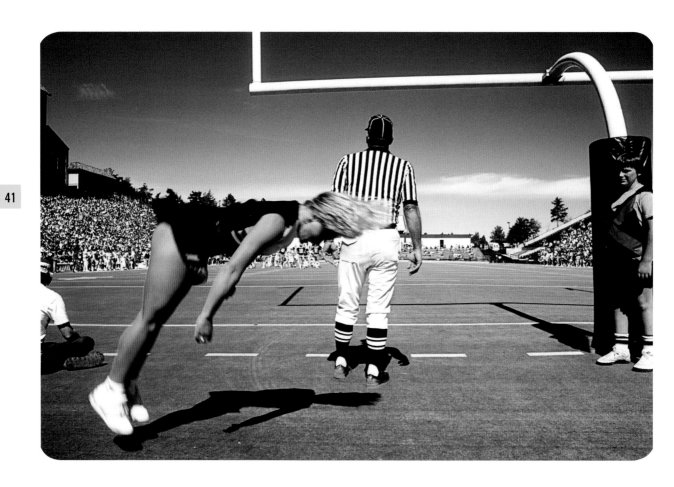

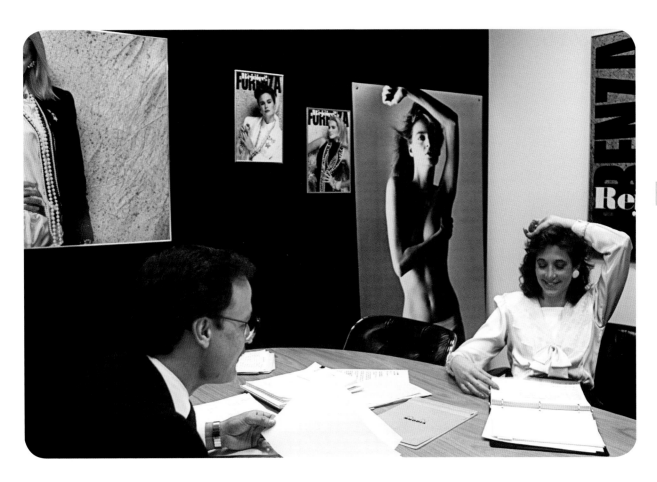

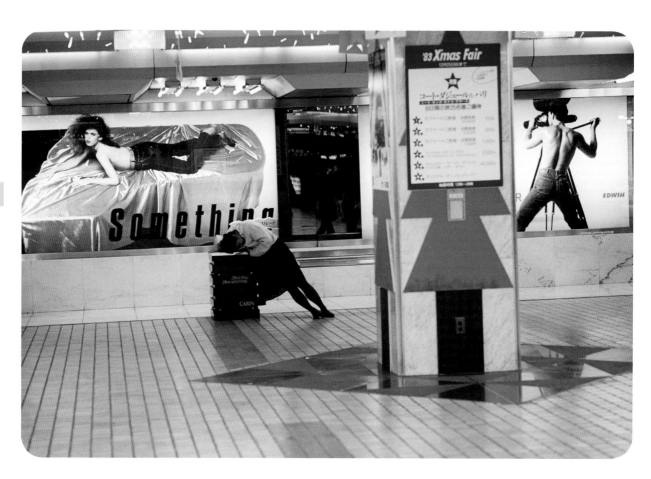

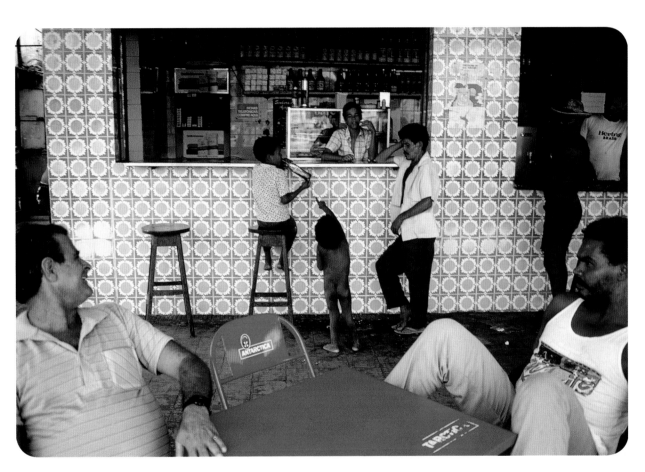

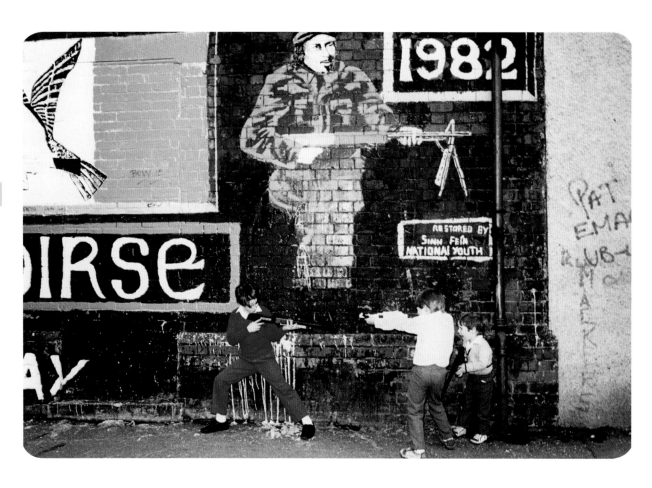

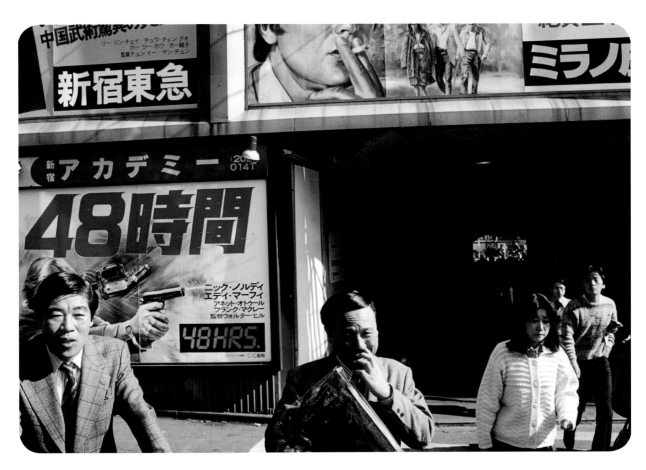

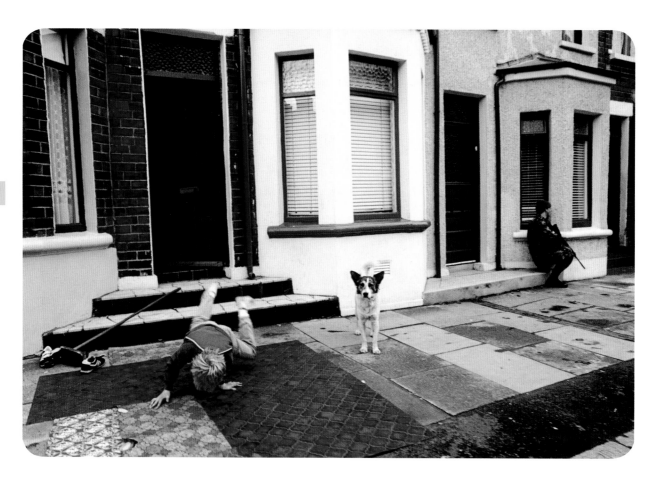

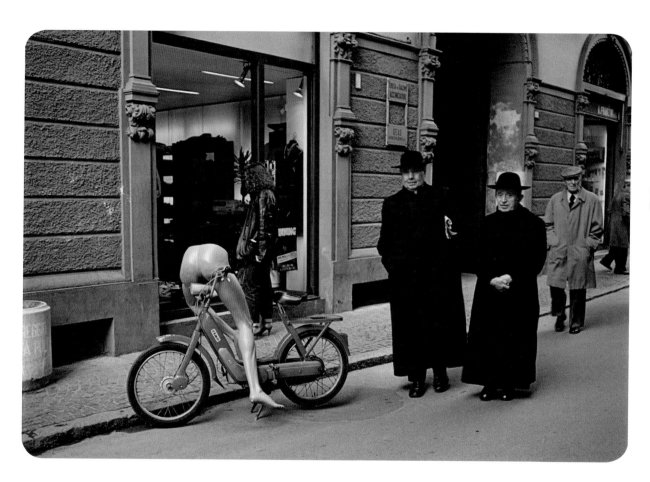

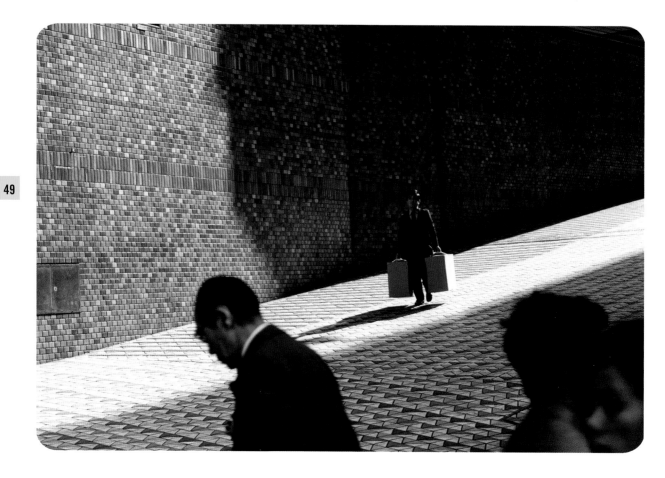

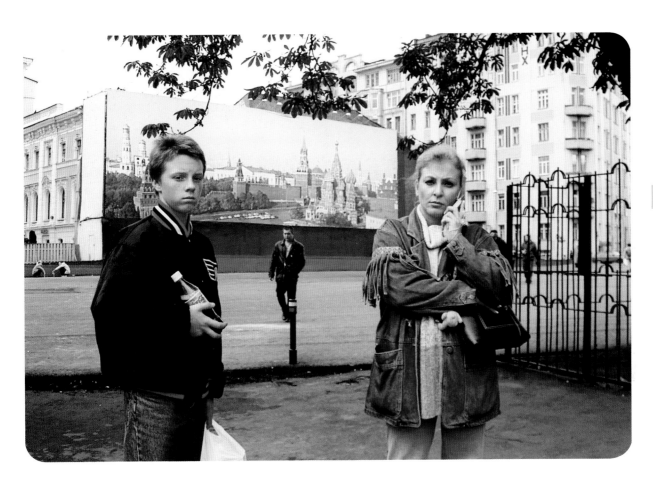

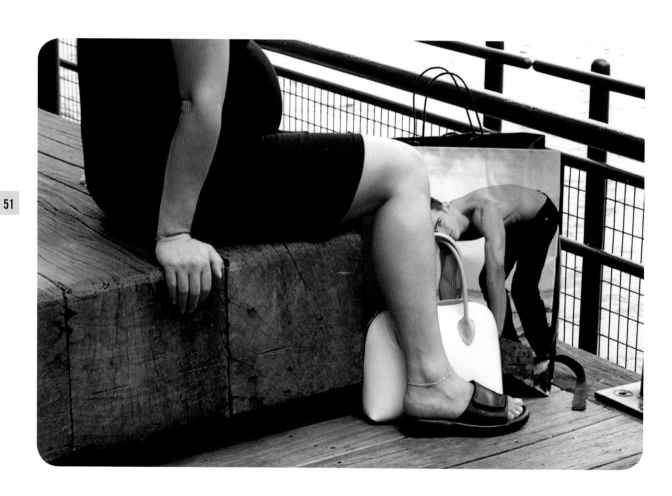

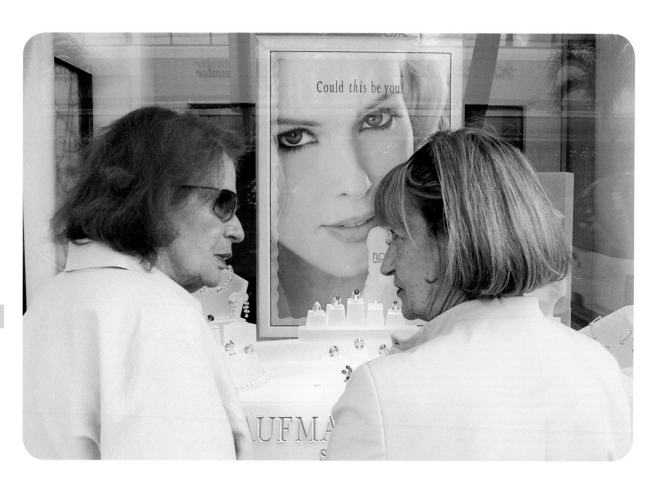

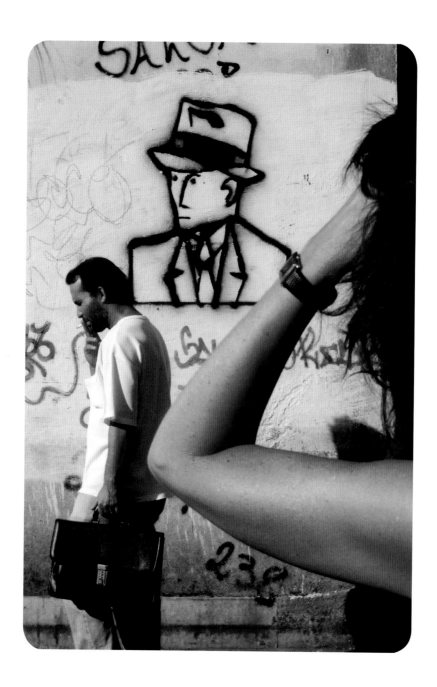

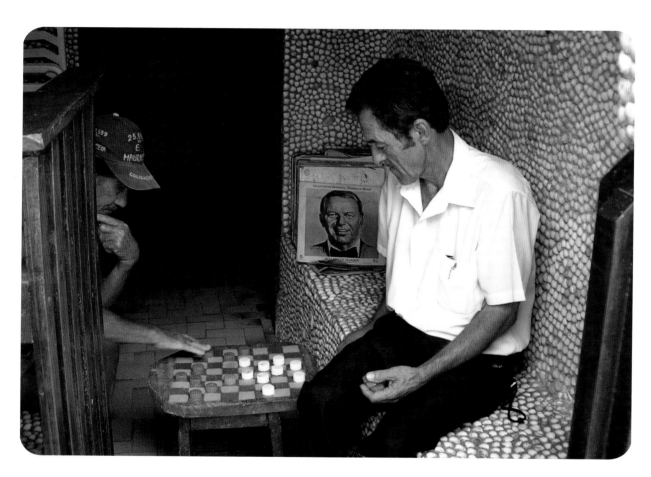

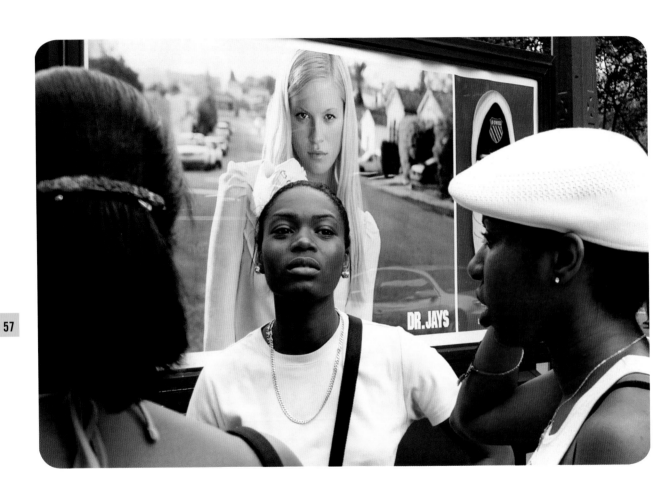

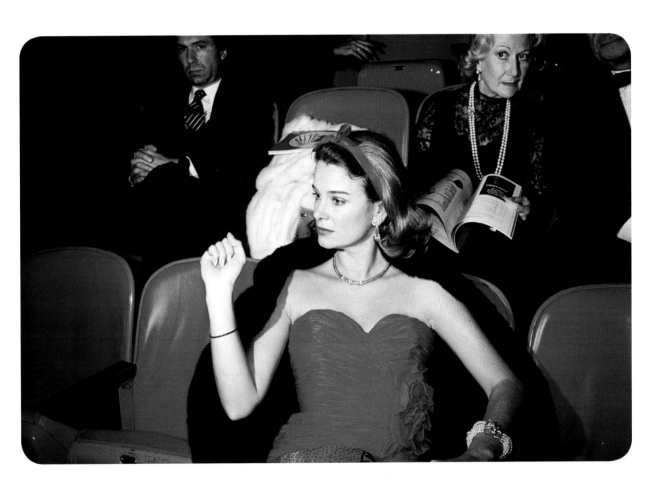

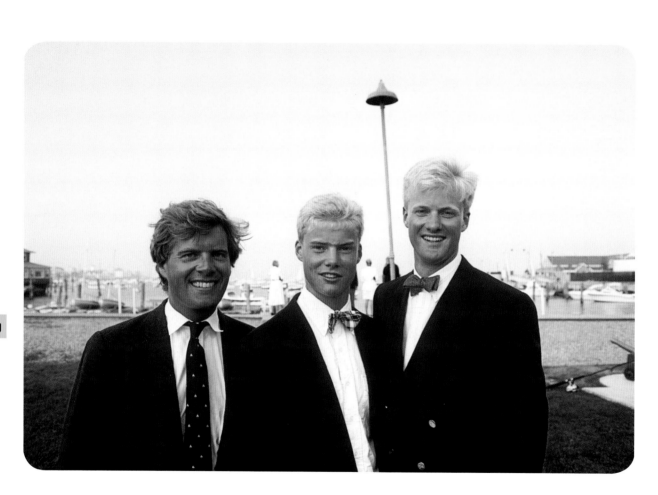

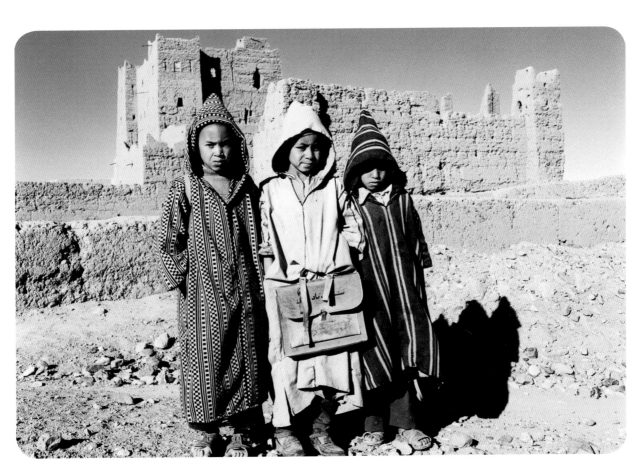

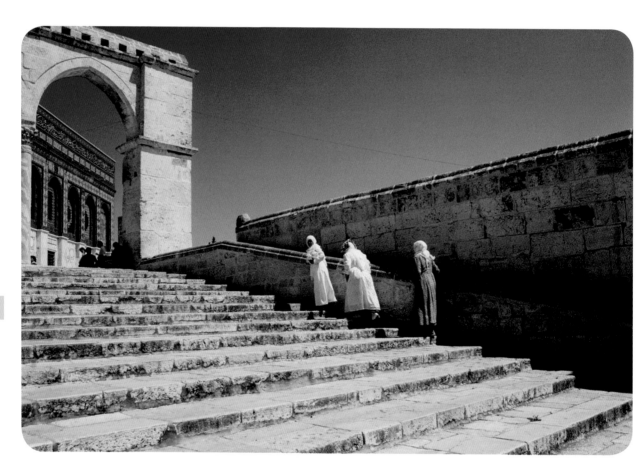

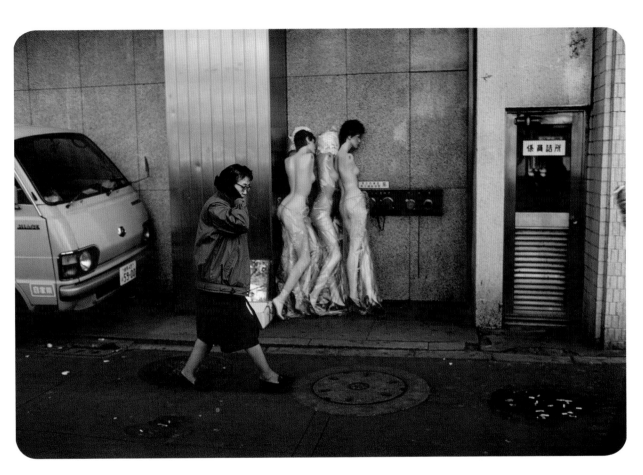

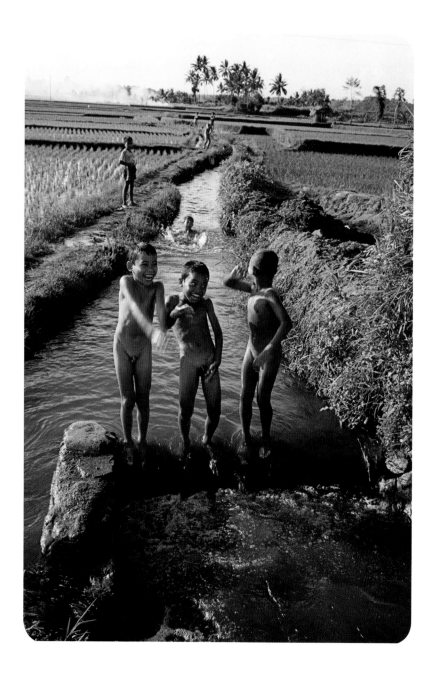

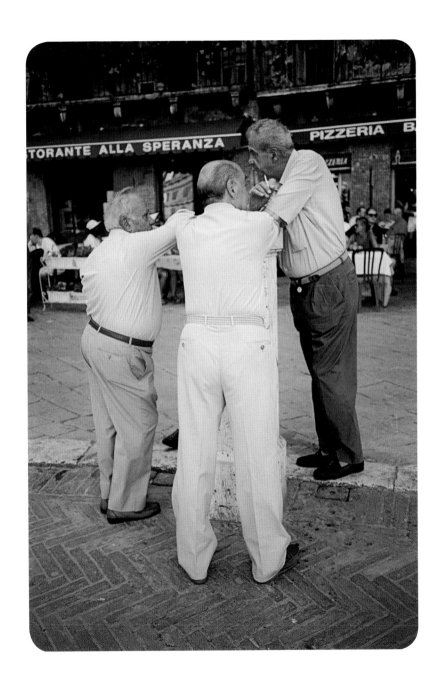

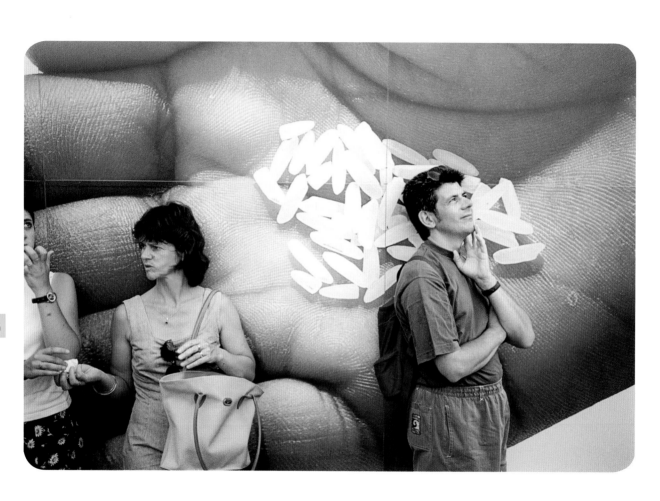

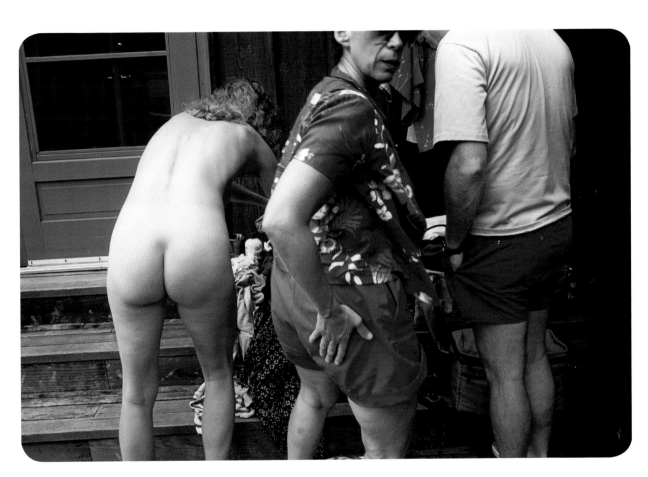

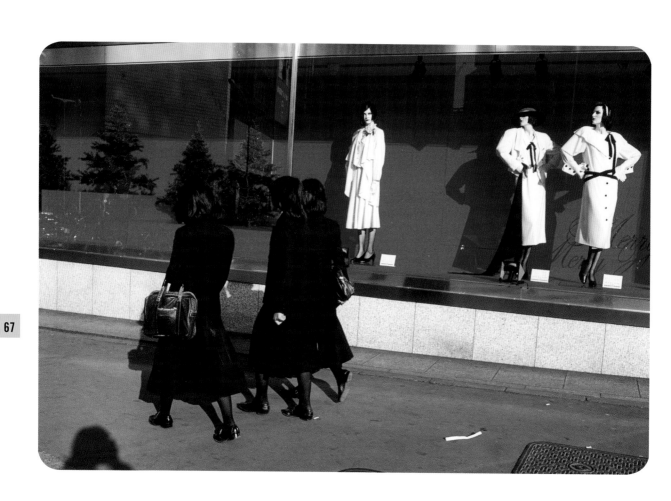

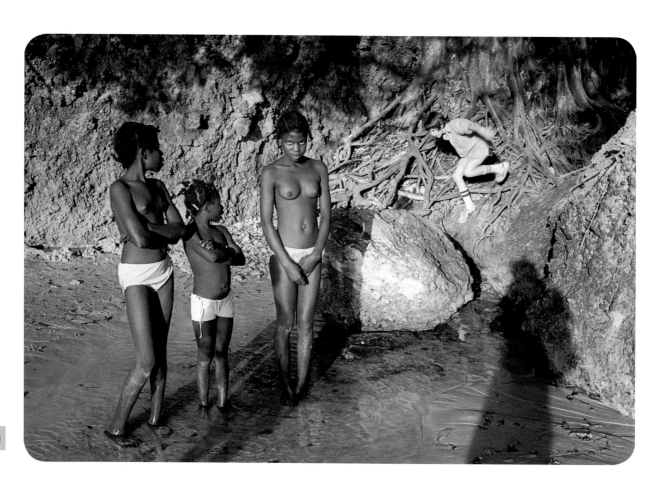

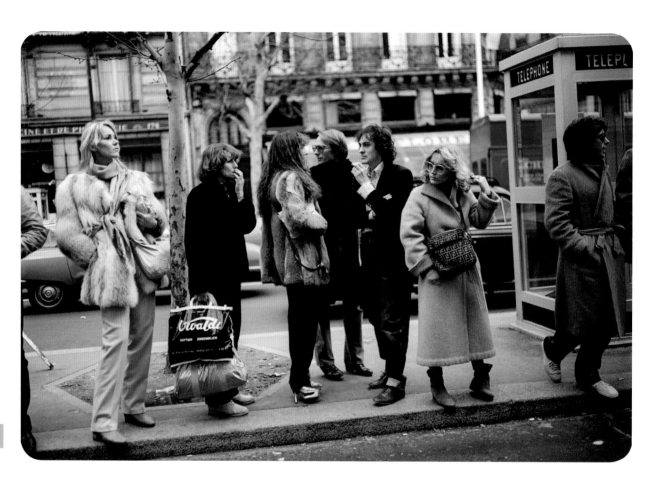

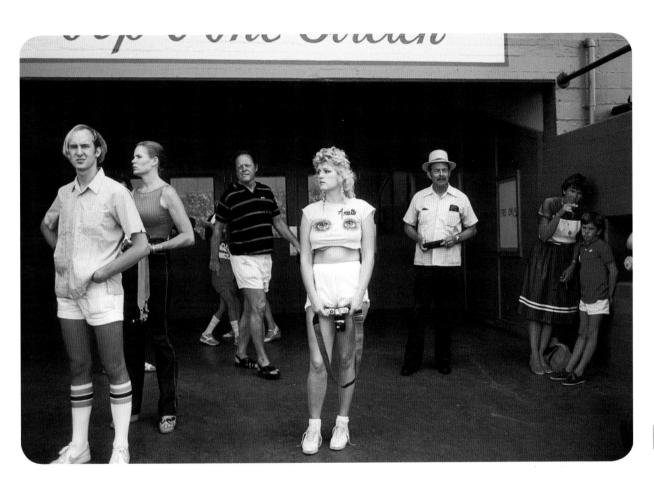

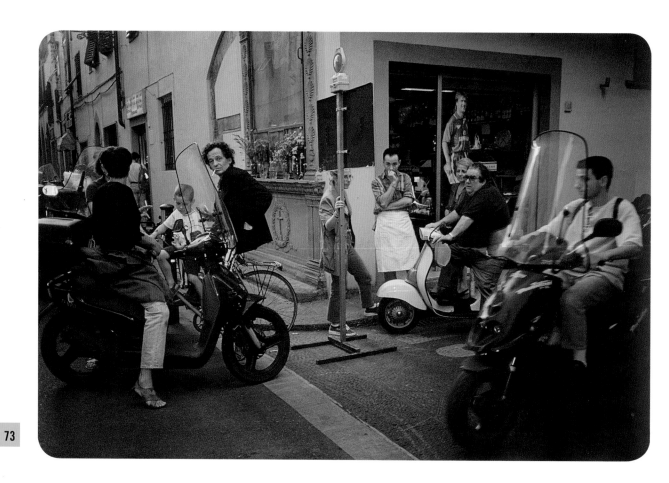

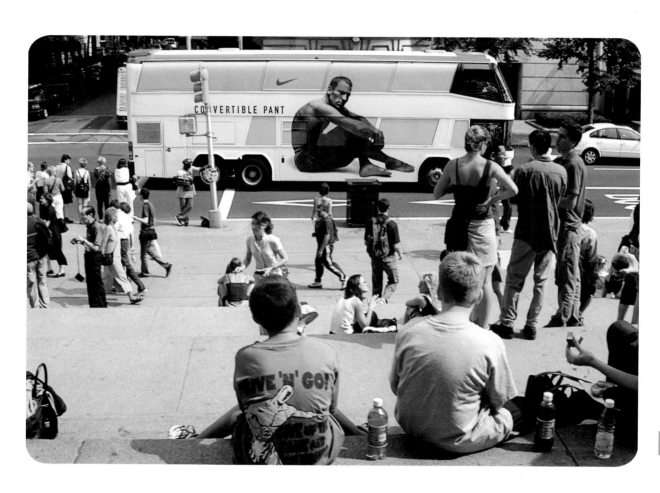

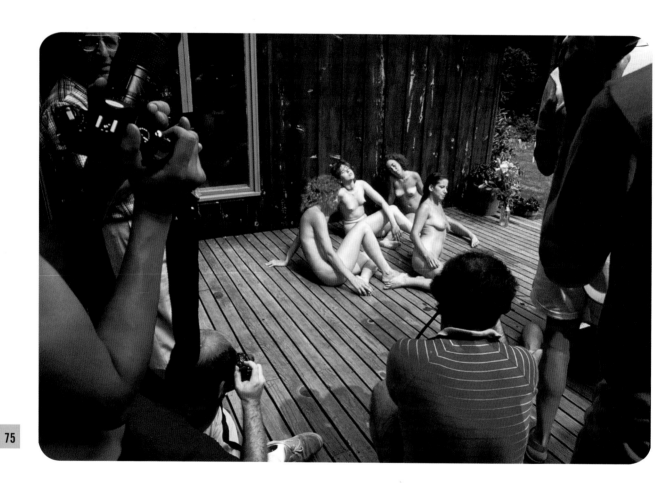

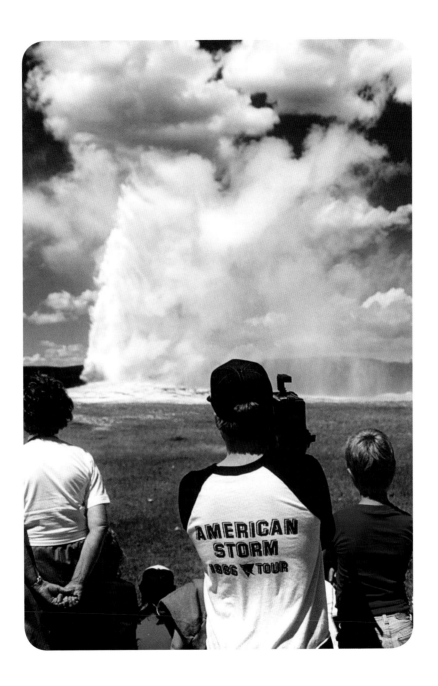

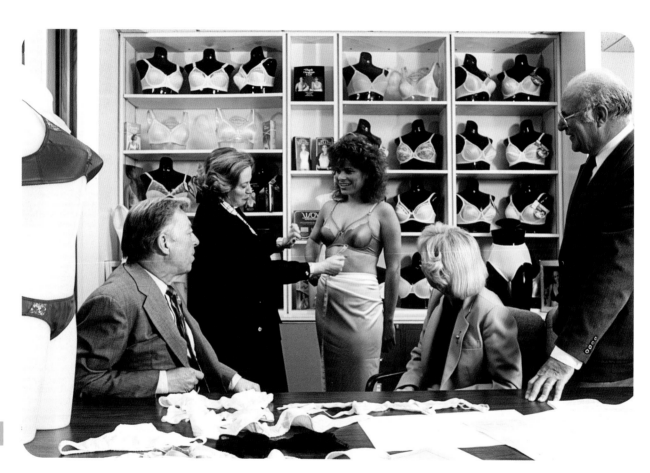

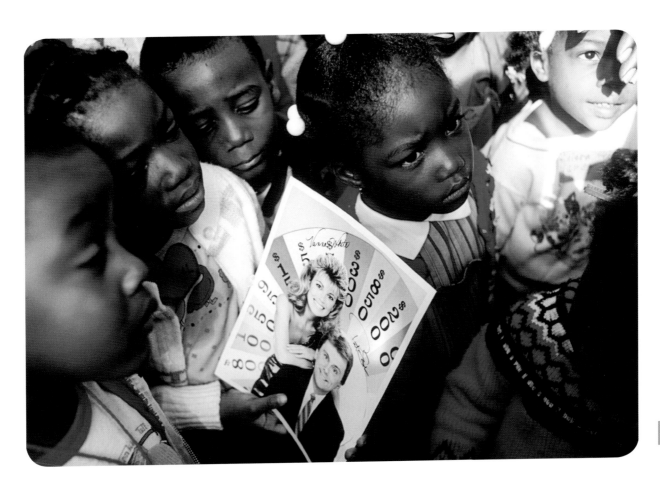

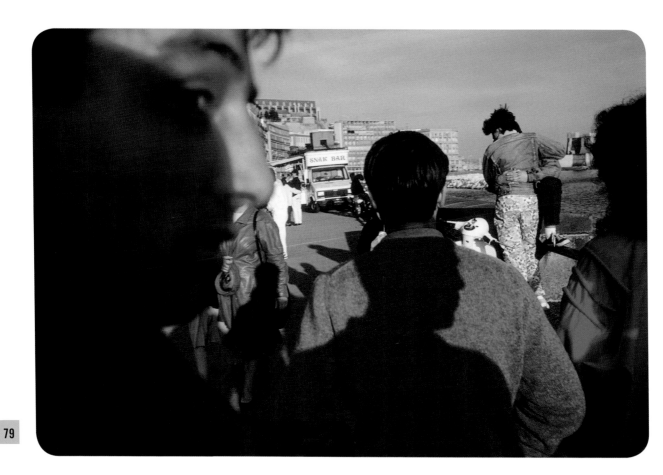

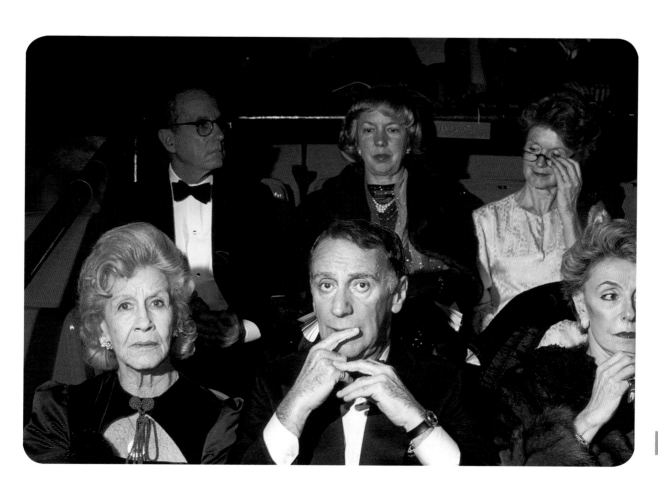

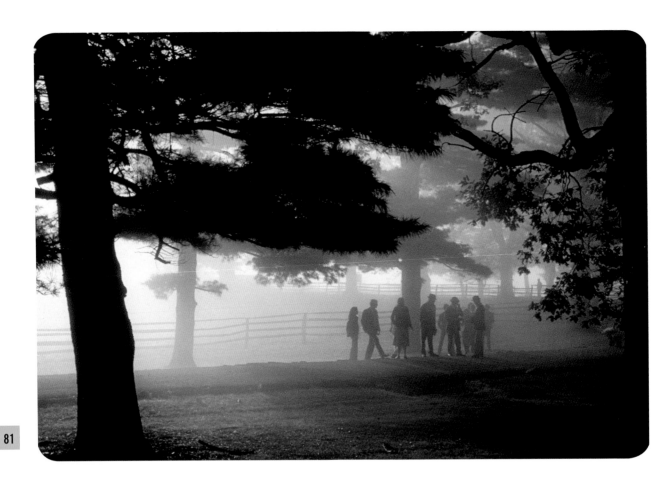

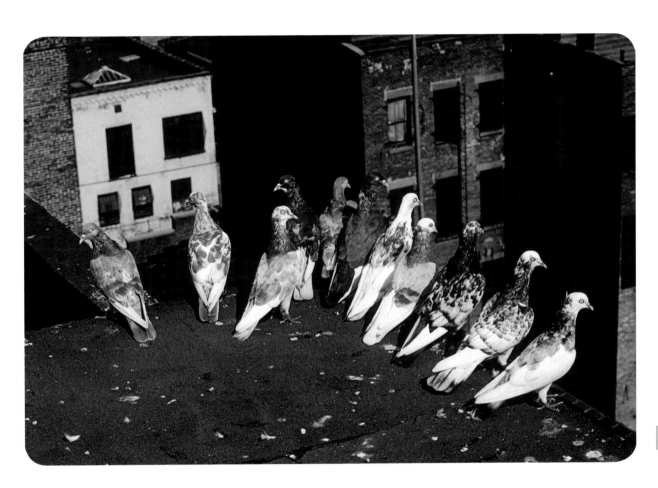

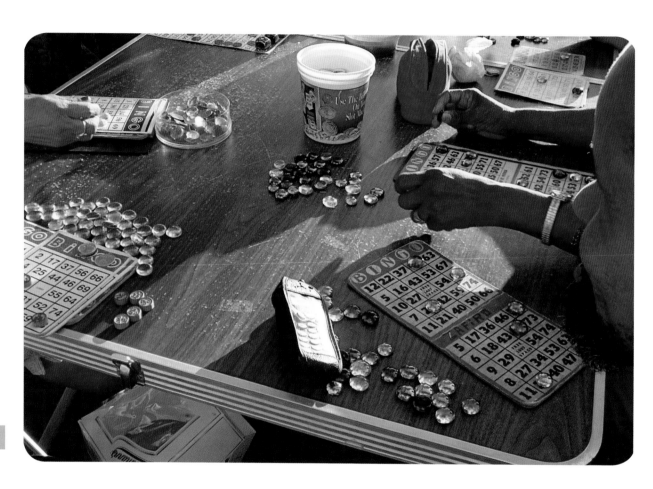

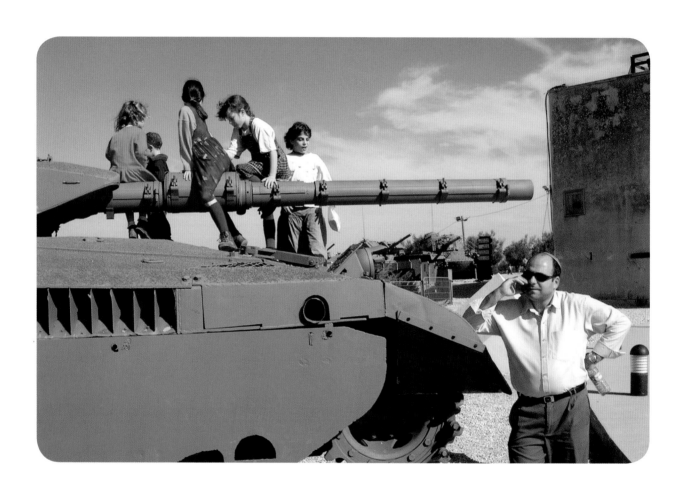

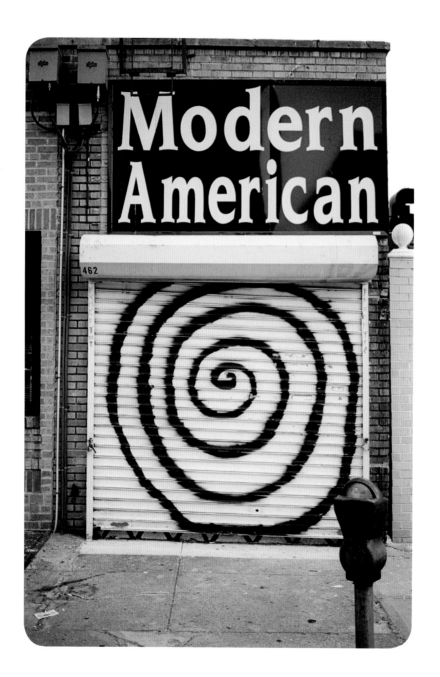

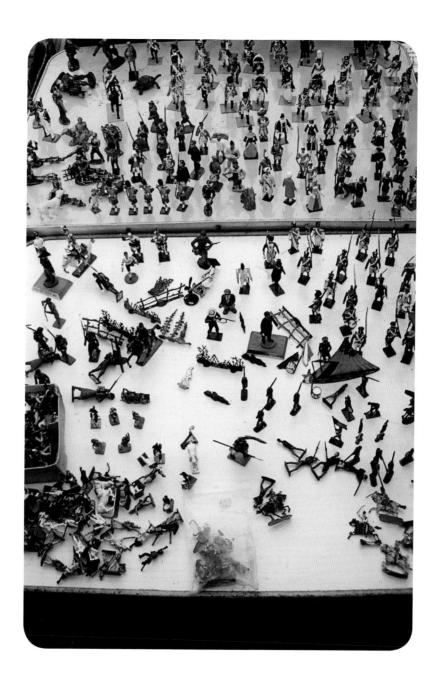

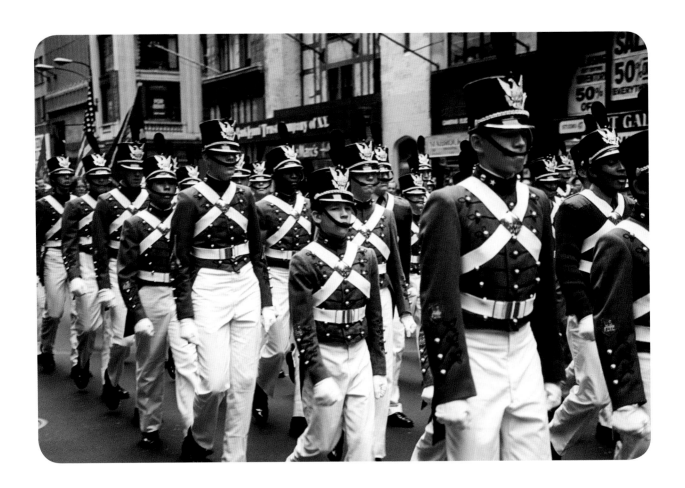

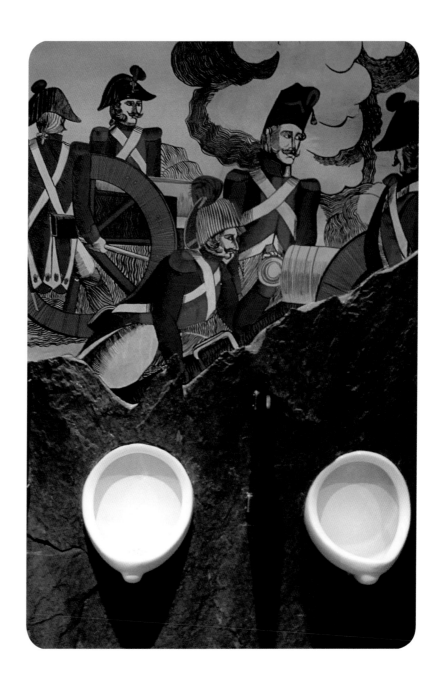

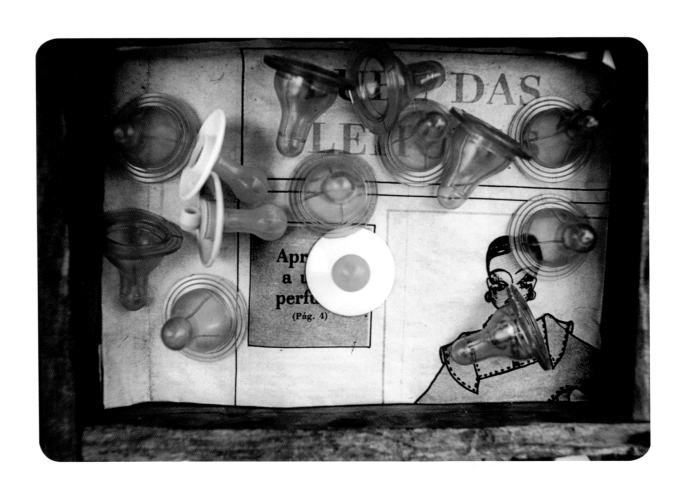

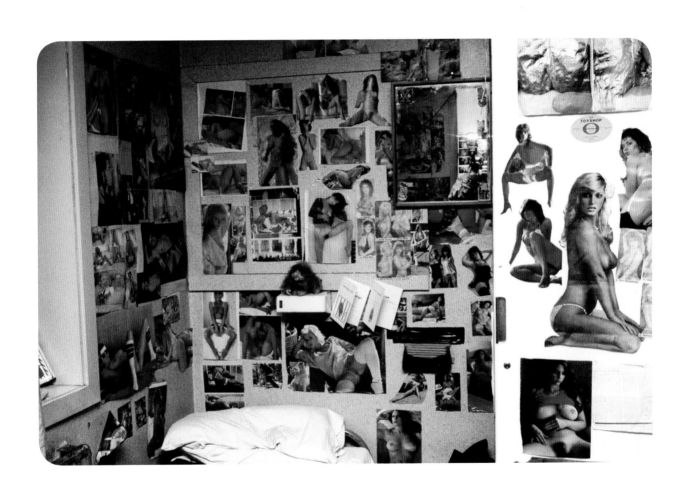

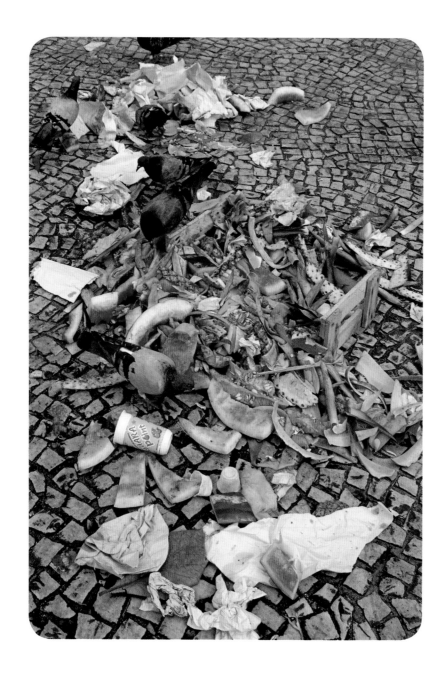

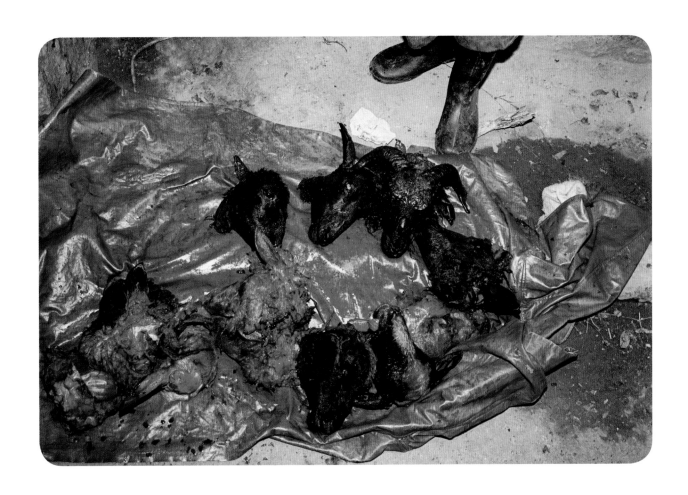

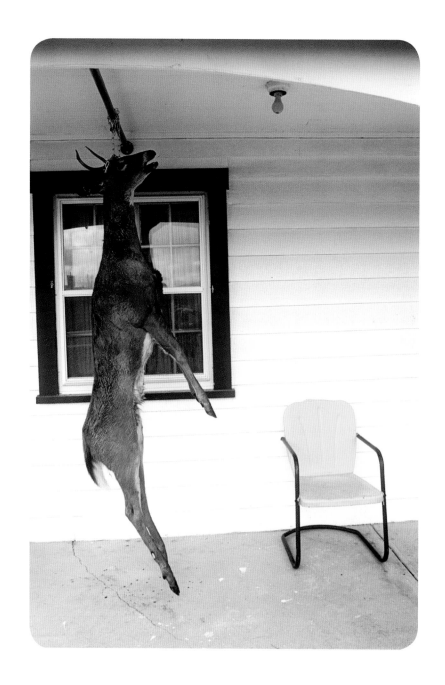

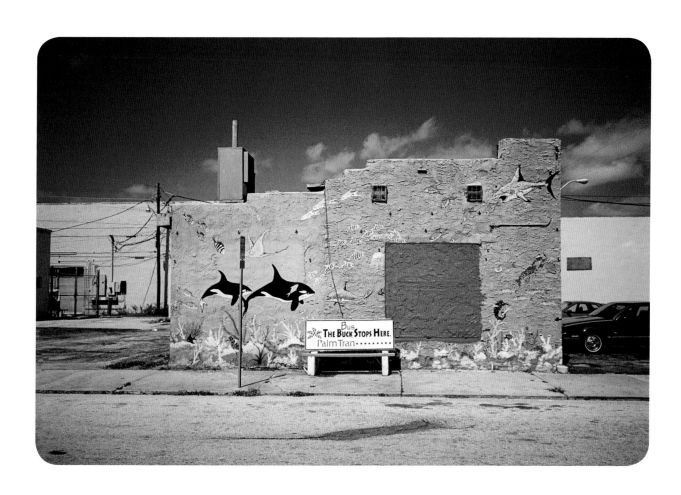

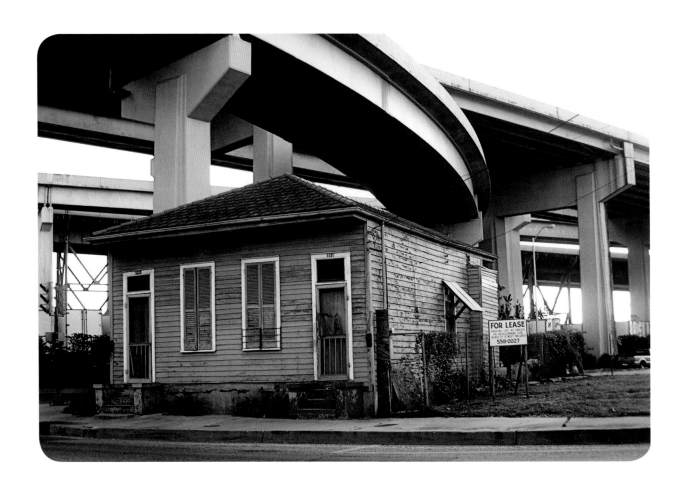

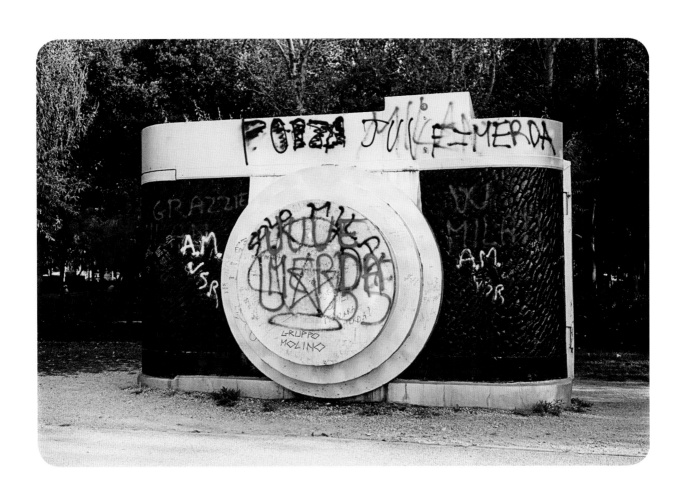

# Afterword BY CHARLES H. TRAUB

The pictures in this book were made from the 1980s to the present. The large majority of them sat for nearly 20 years in a plastic box disassociated from any specific idea. I took them on the fly while conducting other photo business—editorial, commercial, and the like. Only recently did I understand that they are connected and are the impetus for my current work as well. They are all still lifes made from my passing observations of the real world. All the images in this context have transformed the original reasons for their being made. In many cases I can't even remember the exact context. They are ascribed new roles via their ability to stimulate the viewer's own memories or fantasies of their own passing through the social landscape. I hope it is in the strength of these images that they hold different guises for different people and yet remain relics (still lifes) of the period and places in which they were made. For myself, I do not divorce the illusion of the photograph, the self-conscious arrangement from something real in the world that I think I know about.

Many people are responsible for helping to make this book a reality. I wish to thank a number of students and staff of the MFA Photography and Related Media program at SVA who worked on this project in particular Adrienne Deppe, Ross Schwartzman, and Kevin Goggin. Their inspiration, ideas and ingenuity helped to give this book form. Luigi Ballerini, my co-conspirator, deserves my gratitude for his text and his labor in helping to sequence the images herein. I wish to acknowledge the late Jerry Gordon, who was my business partner at the time that many of these images were made and who often shared with me the travel that made these pictures possible. Jim Mairs, my editor and publisher, has been a most generous supporter and ally in producing this book. Finally, with great pride, I thank my son, Aaron Traub whose design inspiration organized this book.

# The Photographs

## CHAPTER THREE

## CHAPTER FOUR

## CHAPTER FIVE

## CHAPTER SIX

*In The Still Life*
Charles Traub
Introduction by Luigi Ballerini

Copyright 2004 by Charles Traub

The text of this book is composed in Trade Gothic
With the display set in Trade Gothic
Book design and composition by Lauren Panepinto & Peter Salvato, Sugarwater Design
Manufacturing by Mondadori Printing, Verona
For information regarding exhibition, licensing, and creative rights
please contact Charles Traub at
www.charlestraub.com

Library of Congress Cataloging-in-Publication Data

Traub, Charles, 1945-
In the still life / Charles Traub ; introduction by Luigi Ballerini.-- 1st ed.
p. cm.
Includes bibliographical references.
ISBN 1-59372-006-8
1.  Photography, Artistic. 2.  Still-life photography. 3.  Traub, Charles, 1945-  I. Ballerini, Luigi. II. Title.

TR654.T7152 2004
779'.092--dc22

2004010285

The Quantuck Lane Press, New York
www.quantucklanepress.com
Distributed by: W.W. Norton & Company, 500 Fifth Avenue, New York, NY 10110
www.wwnorton.com
W.W. Norton & Company Ltd., Castle House, 75/76 Wells Street, London, WIT 3QT

1 2 3 4 5 6 7 8 9 0